Graffiti 4 – latest in the best-selling series compiled by Nigel Rees – is an international survey of all that's brightest and best on the walls of the world. In addition to the usual British and American gems, this time there are special sections devoted to the work of graffiti-writers in Australia, New Zealand and old Pompeii, adding up to nearly 500 examples, old, new, borrowed and blue. As one piece of Australian graffiti, written near the bottom of a door, put it: 'Here's where we get down to the witty, gritty graffiti!'

Also by Nigel Rees in
Unwin Paperbacks
'Quote... Unquote'
'Quote ... Unquote 2'
Graffiti Lives, OK
Graffiti 2
Graffiti 3
Very Interesting. . . But Stupid!
Eavesdroppings
Foot in Mouth

Published in hardback by
George Allen & Unwin
Slogans

NIGEL REES

GRAFFITI

4

London
UNWIN PAPERBACKS
Boston Sydney

First published in Unwin
Paperbacks 1982
Reprinted 1982 (twice)

UNWIN® PAPERBACKS
40 Museum Street,
London, WC1A 1LU, UK

Unwin Paperbacks,
Park Lane, Hemel Hempstead,
Herts HP2 4TE, UK

George Allen & Unwin Australia
Pty Ltd., 8 Napier Street, North
Sydney, NSW 2060, Australia

This edition
© Nigel Rees Productions Ltd.
1982

British Library Cataloguing in Publication Data

Rees, Nigel
 Graffiti 4.
 1. Graffiti
 1. Title
 082 GT3912

 ISBN 0-04-827066-0

Art Director: David Pocknell
Design: David Pocknell's Company Limited
Cover illustration by Eddi Gornall
Typeset in Times New Roman
Printed in Great Britain by
Richard Clay (The Chaucer Press) Ltd,
Bungay, Suffolk

Graffiti 4 takes a more international view of its subject than the first three books in the series. It ranges far beyond the borders of the UK and incorporates substantial scoops of material from the United States, Australia and New Zealand. There is also a section recalling the Roman inscriptions from Pompeii, the forerunners of much modern graffiti. The choice of countries may reflect no more than the fact that I visited them during the course of the past year. On the other hand – apart from Italy – they are all English-speaking countries and I am convinced that graffiti of the type which *say* something and say it humorously, as opposed to those which are simply scatalogical or political, are chiefly an English language pre-occupation.

What never ceases to amaze me is the degree to which the same ideas recur in graffiti throughout the English-speaking world. Like most 'graffitophiles' I tend to believe that when I first encounter a new piece of graffiti (a rare event) then it must be unique. Experience should have taught me that there is always someone in another country to say he saw it *years* ago. 'New' graffiti arise naturally enough through reaction to new personalities and events; 'old' graffiti recur endlessly in an infinite variety of guises. The reason for this lies not so much in the speed of modern communications as in the nature of the English language itself. Because of its richness and variety

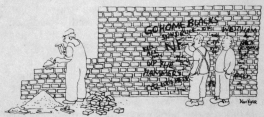

"Him? He's my publisher."

the language lends itself to playfulness. Most of the graffiti in this book are based on puns or other forms of word play. Wherever English is spoken, the same kind of jokes arise, as if by spontaneous combustion.

Accordingly, when a place name follows an item in this book, it records a genuine 'sighting' or the place from which the information was sent to me. But the graffito almost certainly occurs too elsewhere.

Where does this leave the non-English-speaking world? I am happy to include one or two examples of graffiti sent to me from Belgium by Jan Bastiaenssens of Ekeren, though he makes the point that many of the scribblings he comes across in that country are in English. He suggests that foreign words provide a seemingly sophisticated cover for a childish fascination with dirty thoughts. I would add that in Europe English has perhaps become the fashionable language for graffiti because of its role in pop culture.

There may be further confirmation of this in a letter I received from Antero Tammisto of Helsinki shortly after the appearance of **Graffiti 3** in which I passed on the suggestion that Finland was virtually graffiti-free. Antero was keen to correct this view of Finland as the Third World of graffiti-writing and to assure me that it does exist there. Intriguingly, the examples he sent me in Finnish were all translations of well-known English language graffiti – 'Oidipus áitisi soitti' ('Oedipus, your mother called') etc. He also added that many of the graffiti he observed at the University of Helsinki were written in English.

Are there any new themes or types of graffiti on the way in? I am inclined to believe that the examples of the 'so-and-so rules OK' type included in this book may represent the last gasp of that long-running series, especially as advertising

copywriters have now latched on to it. 'Virginian
Rolls OK' was the 1981 slogan for a tobacco, as
was 'Gauloises à rouler – OK.' The only relatively
new strain lies in the 'Do It' series of double-
entendres which, although it has been rumbling
away for a year or two, has now caught on. A digest
of variants is included in this book.

A phenomenon which has affected me
personally is the queue of people waiting to
persuade me that graffiti should not just be limited to
scribblings on the wall. Indeed, a graffito by any
other name would be much easier to spell, but
would it still be a graffito? Dave Straker of Sully,
South Glamorgan, is keen for me to include what
people write on plaster casts. On the foot of his
pregnant wife he reports finding:

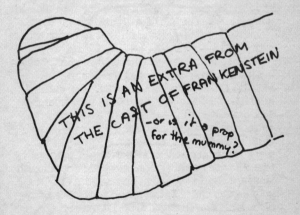

THIS IS AN EXTRA FROM
THE CAST OF FRANKENSTEIN
– or is it a prop
for the mummy?

Godfrey Smith in his **Sunday Times** column even
uses the phrase 'windscreen graffiti' to describe the
large lettered signs people display on the front of
cars:

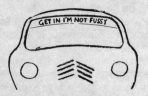

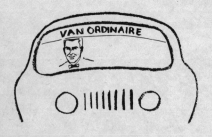

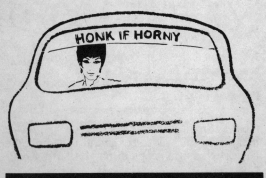

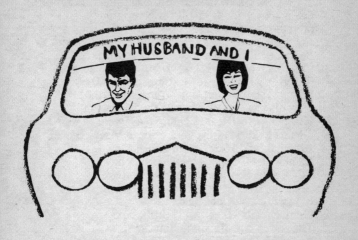

Some correspondents report the smaller car-stickers, usually visible in rear-windows, which they, too, compare to graffiti:

Don't Follow Me, I'm Lost.
> *Houston, Tex.*

My Other Car is a Porsche
> *on Fiat 850*

When I grow up I want to be a Cadillac.
> *on BL Mini*

Just Married. Miss Lucy gonna get some male in her box tonight
> *on limo, New Orleans, La.*

I'm proud to be Irish.
> *making two wrong attempts to spell Irish, this sticker was withdrawn from the market when held to be in breach of the NZ Race Relations Act, July 1981*

A T-shirt spotted on a hugely pregnant girl in Vancouver and saying 'The Secret is Out' prompted another correspondent to write to me saying surely this counts as a graffito. And Rodney Saunders of Elstree made me sit through the 100th Cup Final (and the replay) to observe the placards waved by what seemed to be most of the 100,000 fans at Wembley Stadium. To understand the placards I needed to know that the Tottenham Hotspur football team included players called Glenn Hoddle, Garth Crooks (who is Black), Steve Archibald and Tony Galvin, and that the Manchester City players included Bobby McDonald, Ray Ranson and Nicky Reid:

Reid will leave Archi-Bald.
Garth Crooks – Black Magic in the box.
The power to hold spurs to Ranson.
Bobby McDonald scores more than Emmanuelle.
City have the power to arrest Crooks.
Crooksie invades McDonald's farm.
Garth Crooks strikes better than B.L.
It'll be a doddle with Hoddle.
Ranson will be Galvinised.
(Spurs won).

Still somewhat dubious I also watched the last night of the Proms, which is also an established placard-waving occasion. I only came across 'Am I on TV? and the cryptic 'I'm a normal guy really'.

Finally, after the incident during the Australia v. Pakistan cricket Test at Perth in November 1981 I could not help but agree that the banner saying –
I GET A KICK OUT OF YOU, DENIS LILLEE –
was just the sort of thing a graffiti-writer would have come up with.

This is not an issue I want to lose any sleep over. There is already considerable two-way traffic

between graffiti and lapel-badges and buttons and car-stickers. The same jokes and sentiments recur in all these media. However, my definition of graffiti is that it is the individual expression of an idea, done upon a wall, and, above all, done anonymously. The spirit that animates the graffiti-writer, the placard-waver and the sticker-sporter may be the same, but they are not all one and the same activity. Not in my book, anyway. This definition of graffiti is also probably what clouds my view of the B.U.G.A. U.P. organisation which I discuss in the Australian section.

Nevertheless, my thanks to all those people who have tried to persuade me to venture into new areas. Above all my thanks to the many, many contributors of mainstream graffiti. Acknowledgements and picture credits can be found at the end of the book.

London 1982

STOP PRESS – IRISH BOAT PEOPLE REACH VIETNAM.

Leicester

Does the Iron Lady use Brillo pads? Only her gynometallurgist knows for sure.

Newcastle-upon-Tyne

Polanski's new movie – Close Encounters With the Third Grade.

Princeton, N.J.

SPEECH IM
WUL

THE FONZ IS COOL
– but Elvis is cold.

Edinburgh

MICHAEL FOOT—
IS HE A LEG-END
IN HIS OWN
LIFE TIME?

Woodford Green

*E*verything begins with E.

Bleecker Street,
New York City,
N.Y.

PEDIMENTS

E O. K.

Bristol

A bird in the hand does it on
your wrist.

Bury St Edmunds

The ends justify the jeans.
Derby

Feudalism: it's your count that votes.
University of York

VOTE ANARCHIST.
Canterbury

Fools' names and Fools' Faces are always found in Public places

Los Angeles, Cal.

Billy Carter suffers from peanuts envy.

Oregon City,
Oreg.

PYTHAGORAS CAN'T DO THE CUBE.

Hampstead

~~BR~~ASS RUBBING CENTRE →

amended notice at
St Mary's church,
Oxford

I was an atheist until I realised I was God.

Eastbourne

Keep Britain Tidy. Stay in bed.

Eastbourne

Alimony is the screwing you get
for the screwing you got.
Los Angeles, Cal.

I DI AMIN AM OUT.
*Newcastle-upon-
Tyne Polytechnic*

GET OUT OF ANGOLA
– who's she?
London EC1

Amo, amas,
She was tall
Amas, amat, I
And played with

THE AVERAGE BRITISH FAMILY SPENT £16 A WEEK ON ARMS LAST YEAR
– if they didn't this poster would be in Russian.
Bristol

Whatever happened to the Laughing Policeman?
Hornsey Rise

I met a lass
and slender
'aid her flat
her feminine gender

traditional

Q. What do you get when you cross a donkey with an onion?
A. A piece of ass that makes your eyes water.

New Orleans, La.

If the blonde dancing in the blue dress is reading this – my suspicions are confirmed.

gents, University of Sheffield Students Union

I guess we won't be having a Beatles reunion after all.

Manchester

YOYOS RULE O.. K!

Wimbledon

ANNE BANCROFT IS AN UNDERGRADUATE.

New York City, N.Y.

SMOKING STUNTS YOUR GROWTH

— I haven't got a growth!

University of
Manchester

London W1

**DON'T BAN THE BOMB.
DROP ONE HERE.**
Widnes

Waar komen de professors
vandaan? Uit het westen, want de
wijzen kamen uit het oosten.

(Where do professors come from?
From the West, because the wise
men came from the East.)
Leuven
University,
Belgium

Kan een professor in de hemel
komen?
 Ja, want God is oneiiiiiidig goed.

(Can a professor get into
Heaven?
Yes, because God is infiniiiiiinitely
good.)
Leuven
University,
Belgium

Worm met ervaring. Hier
aanmelden.

 (Worm with experience, please
apply here.)
Cemetery,
Borsbeek,
Belgium

MY KARMA HA

UST RUN OVER MY DOGMA.

MY WIF
AWAY W
BEST F
GEE, I M

Samuel Beckett is Krapp!

London theatre

E'S RUN
ITH MY
RIEND.
SS HIM.

Seattle, Wash.

*B*estiality – 9 out of 10 cats said
their owners preferred it.
London W1

You are now sitting in
possibly the most boring
Toilet in the world. In the
Toilet Wall Popularity Poll
of 1952 this wall came
second bottom. The award
for the Most Infinitely
Boring Toilet Wall going to
the seventh cubicle on the
left in the Vatican.

*University of
Sheffield*

SICK

PEOPLE HAVE BEEN CROSSING TO BOULOGNE FOR 2,000 YEARS.

amended poster,
Waterloo Station,
London

My girlfriend has got sex on the brain.
I only love her for her mind.
Swansea

BRITISH AIRWAYS
– We'll take more fares off you.
Birmingham

BASIL BRUSH
IS A POOF
BUM! BUM!
Stockport

Richard Burton was in the Record Book of Guinnesses.
Letchworth

I TRIED TO JOIN FRONT BUT WAS SMALLER

COMMUNITY DANCING RULES OK KOK.

Deptford

Marlon Brando prefers Stork to butter.

Hampstead
Underground
Station

Cannibalize legalis.

Glasgow

Graffiti have changed de face of de nation.

Southampton

THE NATIONAL MY BOOT SIZE THAN MY I.Q.

Dunstable

Cage birds go on strike now!
Call for pay parrotry!
Worksop

Help me find out who I am?
Do you know this man's family?
Wigan

WELSH CHANNEL NOW
– it's the only way we're going to
get a navy.
Cardiff

DIANA SAID YES TO
CHARLES! WILL DEIRDRE
SAY YES TO KEN?
*in the dirt on back
of large furniture
van, Eastbourne,
the day after the
Royal
engagement
announcement,
February 1981.*

Sheffield Wednesday couldn't
win a game on Fantasy island.
Wakefield

NISHED AS
A PEWT.

Fordingbridge

CHRIST DIED FOR OUR
SINS
CHRIST ROSE FROM THE
DEAD
– follow that!

*on Wayside
Pulpit, Dublin*

This is the lorry it all fell off.
on lorry on M3

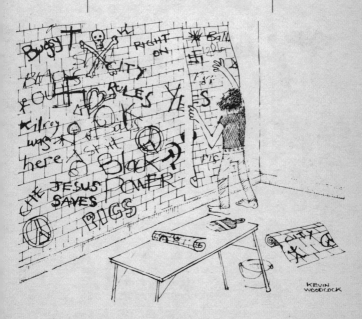

31

PLEASE DC

CIGARETT

ON THE

THE COCK

ARE GETTI

The winter is yours – the
spring will be ours.
*Gydnia, Poland,
February 1982*

N'T THROW

E BUTTS

FLOOR.

ROACHES

NG CANCER.

Barnstable

I've got crabs. Come upstairs
and see my itchings.
Cambridge

WHEN CITY WIN A CORNER THEY DO A LAP OF HONOUR
– that's nothing. Rovers do a lap of honour when they win the toss.
Bristol

I used to use clichés all the time but now I avoid them like the plague.
Stamford

Advice to would-be cloners. Go fuck yourself.
University of Sheffield

A little coitus
Never hoitus.
New York City, N.Y.

These are made from tyres. There are 365 in a Goodyear.
on contraceptive vending machine, Henfield

The Tory party is the cream of society – thick and rich and full of clots.

Cambridge

THE NOLANS ARE TOPS – DESPITE THE KNOCKERS.

Didsbury

MAGGIE CAN'T
DO IT
MICHAEL CAN'T
DO IT
AND YOU CAN'T
MILK CHOCOLATE

Chard

WHY ARE OXFORD STUDENTS LIKE WATER TORTURE?

They're just one drip after another

Oxford

CIRCUMCISION IS
NOTHING BUT A RIP-OFF
– that's a sore point.
– thanks for the tip.
*University of
East Anglia*

The decision is maybe and
that's final.
London EC3

I am
therefore
I think.

IS THIS PUTTING
DESCARTES
BEFORE THE
HORSE?

Nottingham

DRUGS + S
ROCK +
ISN'T LIFE

Hey diddle diddle
The Cat and the Fiddle.
The Cow blew up
On the launching pad.
Harlow Tech.

LOGIC LANE
– Superman's girlfriend.
*addition to street
sign, Oxford*

EX + PUNK

RICHARD.

WONDERFUL!

ladies, Otley

COMING SOON – THE
KING AND DI.
London W1

If it moves, get it to serve you.
*Victoria coach
station, London*

I didn't believe in
reincarnation the last time either.
Whitstable

Donald Duck isn't all he's
quacked up to be.
Liverpool

LEGALIZE DOPE
– Airfix already have.
Blackpool

DWAYNE LOVES DAWN
– nothing is for ever, earthling. All
things begin, are, and end. Even
Dwayne.
*women's rest
room, Purdy,
Wash.*

Irish drama rules, O'Casey.
London theatre

VOYEURS DROOL, OK.
Carshalton

With friends like mine who
needs enemas?
*University of
Leeds*

BAN GROING FASISM
– and higher education.
Leicester

I also stayed with Elsie
Tanner – and the cooking wasn't
much good either.
on lorry on M1

O Come, O Come,
Emmanuelle.
Harrow

eat Drink and be merry
for tomorrow you
may not Die after all

*University of
Sheffield*

If nobody loves you when
you're down and out, does this
mean that they do when you're up
and in?
Cardiff

41

THINK BIG
THINK ERIKA

*on lorry on M6
after Erika Roe
streaked at
Twickenham,
January 1982*

Eschatology's days are
numbered.

*Hemel
Hempstead*

Can one really *know* about
epistemology?

Oxford

I trust Excalibur doesn't
choose this particular stretch of
water to make his reappearance.

Harrogate

Avoid falling hair. Step to one
side.

Wimbledon

"One of these days I'll catch them at it."

THE LAND OF FAIR DINKUM DUNNY

(or where's the Olivia Newton-John?)

Australia's so-called 'cultural cringe' – the feeling that her culture is inferior to that of other countries – happily does not extend to her graffiti. The scribblings in her dunnies (lavatories to poms) are a match for anybody's and her public places, especially in Sydney, are alive with inventive comments about such notable charmers as Prime Minister Malcolm Fraser, vestiges of support for Vietnam draft-resister John Zarb, and comment on the more recent 'Dingo' case in which a couple claimed that a dingo stole their baby from a camp-site near Ayer's Rock. Australia has also given rise to B.U.G.A. U.P. which is not just an acronym – as will be revealed shortly...

Land Rights for Wombats.
Surry Hills,
NSW

P.T.O.

written on a rock,
half the size of a
house, beside the
Great Eastern
Highway leaving
Perth, WA

FRASER DOES THE
WORK OF 2 MEN
— LAUREL AND
HARDY

Carlton, Vic.

Sydney Opera House is off-
Quay.

Lane Cove,
NSW

46

The dingo was framed!

*North Adelaide,
SA*

Goat's Milk — it's Udder Joy

*Coolangatta,
Qld.*

I've always wondered who writes on walls and now I know.

Sydney, NSW

Margaret Whitlam kick starts jumbo jets.

traditional

Pollution is cirrhosis of the river.

*Darlinghurst,
NSW*

47

SHAKE HANDS W

CHEAP SPIRIT

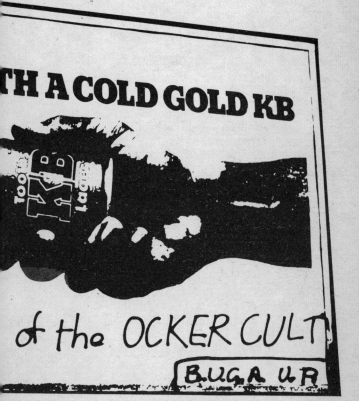

of the OCKER CULT

B.U.G.A. U.R

I am gay. What worries me is
His attitude.

Brisbane, Qld.

Hummingbirds have forgotten
the words.

Adelaide, SA

Millionaires do not live by
bread alone.

*Paddington,
NSW*

LOVE IS A MANY-GENDERED THING

*Camperdown,
NSW*

IN THE GOOD OLD DAYS WHEN MEN WERE MEN AND PANSIES WERE FLOWERS

Darlinghurst, NSW

Masturbation is described as coming unscrewed.
Canberra, ACT

The way to a man's heart is through his penis.
Queensland Institute of Technology, Qld.

ARMS FOR
AFGHANISTAN

— LEGS FOR TITO

Mona Vale,
NSW

*D*efinition of a penis: a
skinhead in a poloneck jumper.
Melbourne, Vic.

I keep thinking I'm the Sydney
Opera House. I must have an
edifice complex.
Elizabeth Bay,
NSW

Linda Lovelace's mother went down on the *Titanic*.
> *Killara, NSW*

Marlon Brando is a yawn-again Fletcher Christian.
> *Bondi, NSW*

Here's where we get down to the witty, gritty, graffiti.
> *at lowest point on wall, Fitzroy, Vic.*

U.S. \neq Us.
> *Richmond, Vic.*

LESBIANS — WHEN ONLY THE BREST WILL DO
> *Sydney, NSW*

GRAFFITI SOON TO BE ERECTED ON THIS SITE.
> *on billboard, Sydney, NSW*

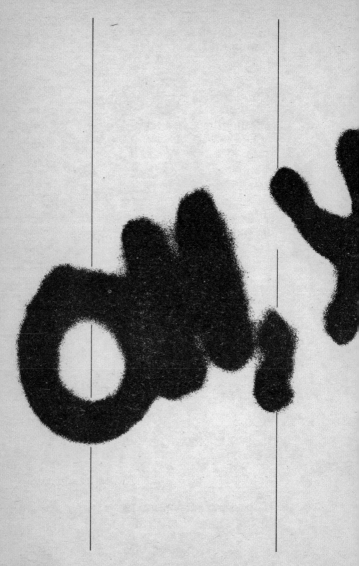

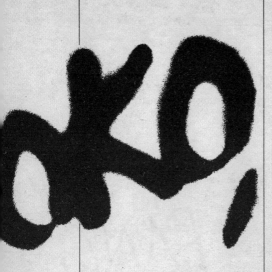

Sydney, NSW,
1981

Don't dye for Reagan. He's
got henna.

Camperdown,
NSW

If pornography relieves sexual
frustration why aren't cookbooks
given to the hungry?

Downer, ACT

FREE ZARB
— Queue starts here.
Sydney, NSW

I've got a soft spot for Vicky
but it's getting harder all the time.
Sydney, NSW

There was an Irishman, an
Englishman and a

BANG!

*Woollahra,
NSW*

GUCCI
GUCCI
GOO

*on side of
accessories shop,
Woollahra,
NSW*

56

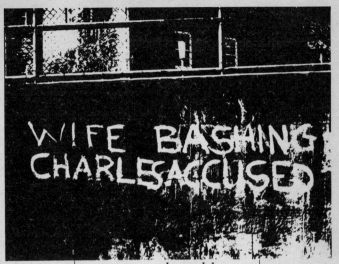

observed the morning after the Royal Wedding, 1981, Sydney NSW

*T*he days of good English has went.

Macquarie University, NSW

*D*onald Duck has been hanged and is now in a state of suspended animation.
Artarmon, NSW

57

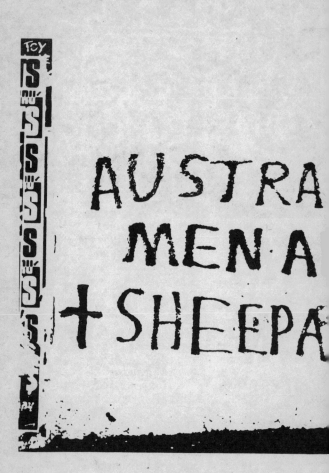

A: WHERE
E MEN,
NERVOUS

Only the Pope and I are infallible . . . but I'm not too sure about him.

Nedlands, WA

It's lonely in the saddle since the horse died

Paddington, NSW

Don't just sit there, do something.

ladies, Lennox Head, NSW

Anyone believing in the Virgin Birth is labouring under a misconception.

Carlton, Vic.

IF VOTING COULD CHANGE THINGS IT WOULD BE ILLEGAL

Carlton, Vic

Waterbeds are cutting down
the incidence of adultery. Why?
Ever tried to crawl under one?
*South
Melbourne, Vic.*

Pick a Pimple for Mother's Day

Brisbane, Qld.

Bo Derek rates Tarzan 'Ape
and a ½'
*East Melbourne,
Vic.*

THE IRISH MURDERING

Richmond, Vic.

Why is a camel called the Ship of the Desert?
Because it's full of Arab semen.
Balmain, NSW

WAR IS MENSTRUATION ENVY.
Carlton, Vic.

Mr Spock uses vulcanised rubbers.
Woolloomooloo, NSW

ARE
PIGS

tell the R.S.P.C.A.

E schew obfuscation.
> *Monash*
> *University, Vic.*

V OTE MAL
EAT PAL

> *Deewhy, NSW*

Be Gay Now
Avoid the Bums Rush.

> *Sydney, NSW*

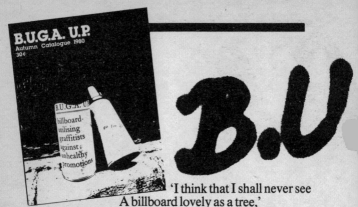

'I think that I shall never see
A billboard lovely as a tree,'
wrote Ogden Nash.
'Indeed, unless the billboards fall,
I'll never see a tree at all.'
In Australia, a group of graffiti-writers going under
the name of B.U.G.A. U.P. has been expressing its
dislike of billboards in its own special way. I
encountered one of its members in Sydney.
"Humour is the greatest weapon of all," said Fred,
"And our mission is to expose the manipulations of
advertisers. So we re-face billboards."
"Don't you mean 'de-face'?" I asked.
"No, re-face. It's not destructive vandalism like
breaking windows. There is a social message
behind it. We are trying to help people."
"I assume you believe in the freedom to
communicate? Why shouldn't advertisers have that
same freedom – unhindered by your activities?"
"Communication is not a one-way thing. Why
should the advertisers have the last word?"

Fred is a member of B.U.G.A. U.P., the
rather heavy-going acronym which stands for
'Billboard-Utilising Graffitists Against Unhealthy
Promotions'. Australia has become well aware of
the group's activities since they began in 1979.
Indeed, you do not have to look far before seeing

B.A. U.P.

Marlboro cigarette ads defaced – sorry, re-faced – with slogans like 'The World is my Ashtray' (the cowboy's horse has a speech balloon coming out of its mouth saying 'Cough, cough.') Dunhill Superior Mild posters get 'paint-bombed' or altered to 'Dunghill Superior Mildew'. Coke ads are overpainted with 'Rotten to the Jaw'. KB Lager is explained as 'Kash for them – Beergut for you.' Many of the spoiled billboards are signed 'B.U.G.A. U.P.'

"Surely you can't be against everything that gets advertised on billboards?" I ventured. "I mean, what's wrong with milk, for example?"

"Totally unnatural," Fred spat out and reeled off various statistics to prove his point. So it is not just tobacco and alcohol that B.U.G.A. U.P. is worried about? "No; it is the whole artifical world that advertisers try to create. Selling useless products to people who don't need them anyway. Besides, billboards are an offence in themselves. They're an eyesore."

"You don't just put squiggles on billboards, you cover them with slogans. Do you use ladders?"

"Oh yes, we're quite blatant about it. Five of us were caught together on one occasion."

"What happened?"

"Two weeks' gaol.

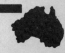

It is not surprising if such mischief-making appeals to a lot of Australians. Most people are probably less worried about poster-vandalism than smashed up telephone boxes and cars. They may feel it is only right that someone should point out the paradoxes in many forms of advertising.

The Outdoor Advertising Association of Australia understandably takes a less charitable view and has been running an all-out campaign to discredit B.U.G.A. U.P..

"Does this campaign against you make you feel you have made your mark?"

"People are more aware of the issues, that's for sure. And they have started posting cigarette ads higher up so that it's harder for us to get at them. That shows a reaction. But we paint-bomb them just the same."

I came to the conclusion that the B.U.G.A. U.P. people were not like the anonymous graffiti-writer who leaves his message or joke and scuttles away. They were a lobby which destroyed what they did not approve of. Although some of the spirit of graffiti-writing proper came through in their pointed humorous additions to posters, they lacked the good-humoured ineffectualness which contributes to the charm of many graffitti-writers.

Home in London, I realised I *had* known about B.U.G.A. U.P. even before I arrived in Australia. I came across a note of a scrawl I had observed on a poster in Green Park underground station and which I had rejected as not being a notable piece of graffiti. 'Join B.U.G.A. U.P.,' it had said, 'Billboard-Utilising Graffitists Against Unhealthy Promotions.'

Another hand had written underneath: 'This degrades graffiti.'

*I*s a flashback a man with his
raincoat on back to front?
Headingley

*F*lush before you rise
And you will get a nice surprise.
ladies,
Northampton

MORSE CODE

*F*OREIGNERS OUT
– I wish I could.
on Berlin Wall

*I*s 40:30:30 an electoral
liability or a pectoral deformity?
Labour Party
HQ, London
SE17

RULES °°°---

University of Sheffield

Contraceptives Should be used on Every Conceivable Occasion

Southsea

F riends may come and friends may go but enemies accumulate.
Harwich

F ROGGIES GO HOME
– et ta soeur?

at camping site in Scotland much used by visitors from the Continent

I 'VE GOT WHAT EVERY WOMAN WANTS
– oh, I suppose you're in the fur coat business.
gents, Ware

B RING BACK FUTILITY
– you just have.
Sheffield

Q. What's the difference between nice women and garbage?

A. Garbage gets taken out at least once a week.
Portsmouth

GATECRASH YOUR
OWN FANTASY
> *Maida Vale*

A gay is someone who likes
his vice versa.
> *Cambridge*

Genitalia is not an Italian
airline.
> *University of*
> *Exeter*

Q How can you
tell if it's an
Alitalia plane?
A. By the hairs
under its wings

> *London W1*

71

LITTLE GIRL, LITTLE GIRL
WHERE HAVE YOU BEEN?
I'VE BEEN UP TO LONDON TO
MODEL FOR 'QUEEN.'
LITTLE GIRL, LITTLE GIRL,
WHAT DID YOU THERE?
STOOD AROUND, LEAPT AROUND,
JUMPED AROUND, BARE.
LITTLE GIRL, LITTLE GIRL,
WHAT HAPPENED THEN?
NOTHING - THEY'RE FUNNY
THESE CAMERA MEN.

Covent Garden

Is it true that posh glue sniffers are stuck-up?

Cambridge

God may be dead but 50,000 social workers have taken his place.

University of Loughborough

GOD IS GOOD, E & OE.*

Kano, Nigeria

Come back Godot, all is forgiven.

Hemel Hempstead

GOLDERS GREEN 2
– but to you, 1½.

amended road sign, North Circular Road, London

* errors and omissions excepted

I TRIED TO
GRANDMOT
EGGS, BUT
IN THE END
THE LID OFF

Gynaecologists, look up a
friend today!

*London teaching
hospital*

Graffiti is squatter's writes.

Harston

EACH MY
ER TO SUCK
GAVE UP
COULDN'T GET
THE COFFIN.

Cambridge

Harakiri takes a lot of guts.
St Albans

Hay! I've been reaped!
Bangor

The difference
and a hedgeho
has all the p

Old hippies never die – they
just take a trip.
Chelsea

She offered her honour.
I honoured her offer.
So all night long
It was on her and off her.
traditional

STOP CRITICISING
WOGS
– this man does for race relations
what Godzilla did for ballroom
dancing.
*University of
Sheffield*

etween this place
, a hedgehog
ks on the outside

University of
Manchester

He who hesitates has lost the
parking spot.

Boston, Mass.

No darling, it only leads to
housework.

Kentish Town

Humpty Dumpty sat on a wall,
Humpty Dumpty had a great fall,
All the King's horses and all the King's men,
Had scrambled eggs for the next four weeks.

Hertford

I'M TWELVE INCHES LONG AND THREE INCHES ROUND
– that's fine, but how long's your prick?

traditional

Definition of an Irish cocktail: a pint of Guinness with a potato in it.
Cardiff

I do

There has been a run of car-stickers since the late 1970s promoting various sporting and other organisations with slogans based on the words 'do it'. Among them:

Hang-gliders do it quietly.
Windsurfers do it standing up.
Waterskiers do it in rubber suits.
Squash players do it against the wall.
Skiers do it on the piste.
Swimmers do it with the breast stroke.

. . . and so on. There was the ad. slogan 'You can do it in an M.G.' and the Qantas car-sticker 'Do it Down Under'. Inevitably, graffiti variants were soon to hand, promoting little more than double-meanings:

Shot putters do it on one leg.
Squatters do it sitting down.
Tommy Cooper does it just like that.
Monks do it habitually.
Art students do it with their brushes.
Trombonists do it in any position.
Wildlife biologists do it like animals.
Builders do it with erections.
Artists do it with imagination.
Printers do it and don't wrinkle the sheets.
Musicians do it by the score.
Charles and Di do it by Royal Appointment.
Broadcasters do it with frequency.
Philosophers do it thoughtfully.
Bankers do it with interest.
Teachers do it with class.
Firemen do it for anybody.
Snooker players do it bending over.
Debaters do it orally.
Tennis players do it with luv.
Kamikaze pilots do it once.

I'm going though an identity
crisis.
(Signed) Gerald, Geraldine and
George III.
Oxford

I FIRST MET MY HUSBAND HERE

-so did I. Isn't he great!

*on bus shelter,
Widford*

Jog – and die healthier.
Sheffield

I was here before Kilroy.
(Signed) Mrs Gladys Kilroy.
Blackburn

YOUR KING IS A
WOMAN
*written up by
Egyptians at time
of Suez to annoy
British troops*

KILROY IS DEAD.
*Market
Harborough*

How come there's only one
Monopolies Commission?
Covent Garden

What did morons do before
they invented CB?
Basingstoke

JESUS LOVES ME
– oh no, I don't!
– why don't you?
– cos, you're a liar.
– oh no, I'm not.

~**don't argue with my Son!**

Brighton

Beware of the Jewish Maffia.
Kosher Nostra?
Dagenham

JOIN THE NATIONAL
FRONT
– use superglue only.
Bristol

What lies behind every
Watergate? A Milhous.
Knoxville, Tenn.

A kiss is like a spider's web. It
often leads to the undoing of flies.
*on bus shelter,
Thatcham*

Legal tender is the night
West Bromwich

GOOD
MORNING
LEMMINGS

*on successive
arches under the
M4, approaching
London*

LENIN LIVES
– but McCartney rocks.
*Clapham
Junction*

Letter bombs are post
mortems.
Leatherhead

I love life but it's unrequited.
Denbigh

Lloyd George *was* my father!
Woodford Green

GIVE ME LIBRIUM OR GIVE ME DEATH

Allentown, Pa.

Support the Liberal Party and
widen the circle of your friends.
*Newcastle-upon-
Tyne Polytechnic*

ROOM FOR ONLY SIX
PERSONS
– or one opera singer.
*amendment to
notice in lift at
Sadler's Wells
Theatre*

LIMBO DANCERS ARE
UNDER-ACHIEVERS
Stroud

LITTLEHAMPTON
WELCOMES YOU**R MONEY**
*amendment to
road sign on
A259*

LOOT BRITISH
*Notting Hill
Gate, 1981,
during riots*

DOCTOR'S LOUNGE –
and they get paid for it.
*amended notice
at St Thomas's
hospital, London*

Let's screw, my finger's tired.
*traditional
translation of
Lucky Strike
slogan –
'L.S.M.F.T.'*

Malicious damage rules.
*on poster,
Tottenham Court
Road
Underground
station*

The earth shall inherit the
meek.
Runcorn

Bestiality – a poke in a pig.
Oxford

HEY DON'T KNOCK MASTURBATION. IT'S SEX WITH SOMEONE YOU LOVE.*

Amsterdam

* also a line in Woody Allen's
film *Annie Hall*

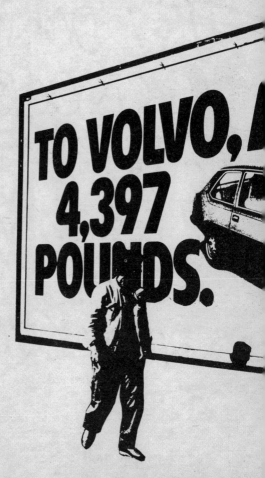

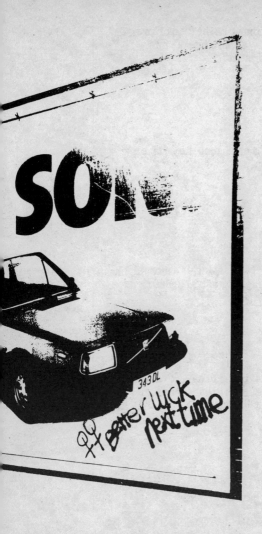

If music be the food of love,
how about a bite of your
maracas?

*Welwyn Garden
City*

Come on then. Let's have a
reply.

*isolated graffito,
University of
Sheffield*

Manslaughter is a terrible
thing. Woman's laughter is even
worse.

Lichfield

It is better to have loved and
lost, than to have paid for it and
not liked it.

London WC2

BRITISH RAIL IS GOD'S
WAY OF TELLING
YOU TO SLOW DOWN

Surbiton

It is difficult to explain to
white mice that black cats are
lucky.
Covent Garden

Keep Britain Tidy. Give
Michael Foot a haircut.
Heaton Moor

The Lord said to Moses, come
forth – but he came fifth and got a
rubber duck.
Leicester

I thought Mother Goose was a
text-book by Freud until I
discovered Smirnoff.
London W1

Wyatt Earp rules, OK corral.
Corby

Necrophilia means never
having to say you're sorry.
Wandsworth

LLANFAIRPWLLG
WYNGYLLGOGERYCHW
YRNDROBWLLLLANDYSI
LIOGOGOGOCH
– O.K.

*addition to
station sign,
Llanfair P.G.*

I F YOUR N
AND YOUR F
YOU MUST BE

1984 came in 1977, but not enough people noticed.
Newcastle-upon-Tyne

WOMEN SAY 'NO' TO MALE VIOLENCE
– Men say 'no' to female graffiti.
Clapham Junction

OSE RUNS
EET SMELL
UPSIDE DOWN

Wakefield

THE LAND OF THE

Aotearoa is the Maori name for New Zealand. It means 'The Land of the Long White Cloud'. A graffiti-writer changed this to 'The Land of the Wrong White Crowd' during the tumultuous events surrounding the visit of the South African Springboks rugby team in 1981. The effect on New Zealand of this controversy was – to compare small with large – rather like that of the Vietnam War on the United States. It polarised opinion and unleashed a protest movement which took to the walls to proclaim its message – 'No Tour', 'Stop the

LONG WHITE CROWD

Tour', 'Ruck Off, Boks', and so on. Prime Minister
Robert (Piggy) Muldoon said of the
Commonwealth opponents of the trip, 'My first
reaction was to tell them to find a good taxidermist.'
The tone having thus been set, the debate continued
beyond the tour and as far as the November
General Election in which Muldoon managed to
scrape back into Parliament ('The Beehive'
building) in Wellington having narrowly defeated
such rivals as Bill Rowling with a platform entitled
'Think Big'. Now read on . . .

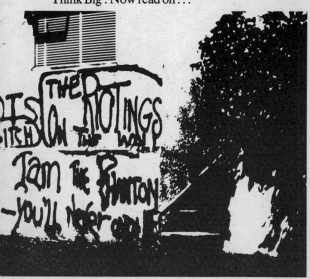

THE RIOTINGS ON THE WALL
Auckland

PIGS DISOWN MULDOON
on bacon factory wall, Ponsonby, Auckland

Avoid rape, dress sensibly.
Auckland

A kiwi is a creature which eats roots and leaves.
Palmerston North

PREVENT HANGOVERS STAY DRUNK

*Palmerston
North*

Think Big. Sink Pig.
*Palmerston
North*

New Zealanders are dumb.
We're the only country that put a
pig in a beehive.
*Palmerston
North*

STOP THE TOUR
– and writing on our fence.
*Palmerston
North*

How can acne be the work of a sane God?

Wellington

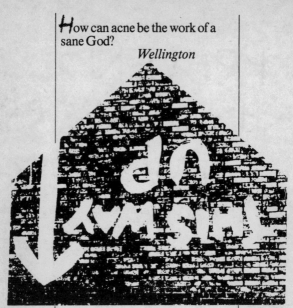

Auckland

Democracy is too good to share with just anybody.

Auckland

The United States has Ronald Reagan, Johnny Cash, Bob Hope and Stevie Wonder. New Zealand has Rob Muldoon, no cash, no hope, and no bloody wonder.

Auckland

MULDOON SAYS 'I'VE
STUFFED GLEN EAGLES,
NOW I'M INTO LAURA
NORDA.'
Wellington

Mr Muldoon
is our pry
minister

Auckland

FOR SALE:
POLICE BATONS
(SLIGHTLY
DAMAGED)

Auckland

99

Rob Muldoon before
he robs you and Bill
Rowling before he
bulls you.

Auckland

Will the last Person to leave New zealand Please feed the PIs

Auckland

AUSSIES HAVE AN UNDERARM PROBLEM!

Wellington, following an incident in the 1981 Test between Australia and New Zealand when Greg Chappell ordered the last ball to be bowled underarm to forestall a New Zealand victory.

GOD BLESS OUR POPEYE

Liverpool 8

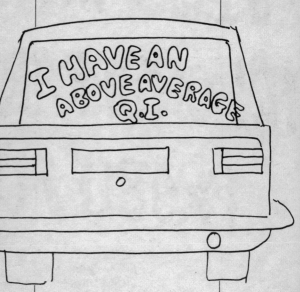

*in dust on back of
car, Liverpool*

Do nuns play hymns with
bananas?

Barri

SAVE MONEY ON OBSCENE PHONE CALLS. REVERSE THE CHARGES

Birkenhead

One-legged guls are a pushover.

Galveston, Tex.

For a close encounter of the fourth kind, ring ********
Fort Lauderdale, Fla.

Oral Sex! All you ever do is
talk about it.
Morecambe

GEORDIES RULE K.K.K.
London W4

FIGHT LOW PAY
– work harder.
Letchworth

PENA

– the last

Penarth

I have finally devised a way to make my penis two feet long – fold it in half.

traditional

Picasso paints by numbers.

Hertford

If pigs could fly, Scotland Yard would be the third London airport.

London W1

RTH

resort

While you're reading this, I'm reading this, I'm picking your pocket

Cambridge

PISCATOR – pis-tacor?
*amendment to
name-plate on
Paolozzi
sculpture at
Euston Station*

I'D RATHER SCREW
THE PIZZA AND EAT THE
WAITRESS
– I did. The pizza's better.
Chicago, Ill.

My husband sleeps under the bed. I think he's a little potty.
Swansea

Many things can be preserved in alcohol. Dignity is not one of them.
Northampton

GRAFFITI is the curse of the cleaning classes
Leeds

Puns don't kill people. People kill people.
Lincoln Park, Va.

POMPEII REVISTED

We use the word 'graffiti' to describe informal messages written on walls largely because of the Roman inscriptions uncovered when Pompeii was excavated from the late 18th Century onwards. Quite apart from formal carved inscriptions and slogans painted on walls, the fatal eruption of Vesuvius which buried Pompeii and nearby Herculaneum in A.D.79 also preserved the scratched comments on political, scatalogical and lavatorial matters that the Romans had made. 'Graffiti' is derived from the Italian 'graffio' = 'a scratch'. So the word has come to refer to any kind of drawing or writing similar in essence to what the Romans left behind them. From these examples in translation it will be clear that the pre-occupations of Pompeian graffiti-writers were largely the same as those of today's, even if their sense of humour was more elementary . . .

Appollinaris, physician to the
Emperor Titus, had an
exceedingly good shit here.

OLD FATHER

KISSES TH

WHERE HE S

My host, I've wet the bed a lot.
I could not find the chamber pot.

The blonde told me to lay off
brunettes. I will if I can. If not, I'll
lay on them all.

110

Vibius Restitatus slept here all
on his own and wishes his
Urbana had been with him.

COLEPIUS
E GIRLS
HOULDN'T

May I always have it off as
well as I had it off here!

Here I recall I had a girl of late
—The intimate details I shall not
relate.

111

IF YOU WRITE
ANYTHING ON THIS WALL-
MAY YOU AND YOUR
NAMES BE LOST FOREVER,
MAY THE POMPEIAN VENUS
RISE UP AGAINST SUCH
VANDALS, AND MAY
THE WRATH
OF ALMIGHTY GOD
DESCEND UPON
SUCH NUISANCE-MAKERS

*a house-holder's
warning to
graffiti-writers,
prior to AD 79*

SI PRIGA IL PUBBLICO DES VIGATA
TORI DI ASTENERSI DALLO SCRIVERE
SULLE PARENTO COMUNIQUE DANNES
GIARE DINTONACO DIPINTO PROVO
CANDO IL DETERIORAINENTO ETALO
RA ANCHE A DISTRUZIONE DELLA
DECORAZIONE PARIETALE

LA SURVO 21

PLEASE DO NOT WRITE OR
SCRATCH ANYTHING UPON THE
WALLS CAUSE NO DAMAGE TO
WALL COATS!

THE SUPERINTENDENT
TO THE RUINS OF POMPEII

notice from
the
Superintendent
to the ruins of
Pompeii, AD
1981

There's nowt so folk as queers.
> *on poster for*
> *ceilidh organised*
> *by Gay Society in*
> *northern*
> *university*

Danger: radioactivity – I'm
listening to the radio.
> *Barnet*

Confucius he say no such
thing as rape. Lady with skirt up
run faster than man with trousers
down.
> *Sheffield*

HELP – female
rapist wanted
urgently
> *ditto*

Reagan ~~CARTER~~ BREZHNEV
JUST THE SAME
WE WON'T PLAY IN
YOUR WAR GAME
> *Madison, Wis.*

Here I sit, broken-hearted,
Spent a penny and only farted.
traditional

Either supply loo rolls in here
or make your receipts bigger.
ladies,
supermarket,
Nottingham

Rectitude is a pain in the bum.
Edinburgh

Trim BBC expenditure. Re-
cycle Nigel Rees.
Oxford

'Now take this, Miss Smith, "All women are slaves"'

Democracy rules 40% OK,
45% NO, 15% Don't know.
University of
Sheffield

Revolution is the opium of the
intellectual.

> *Stockport (also*
> *featured in film*
> *'O, Lucky Man')*

GRAFFITI IS A COTTAGE INDUSTRY

Cudworth

Roddy Llewellyn had a part in
Charlie's Aunt.
> *Cambridge*

WHEN IN ROME, DO AS
THE ROMANS DO. SHOOT
A PREMIER.
– come to that, why bother to go to
Rome? Do it here.
> *Covent Garden*

Whatever happened to
Rosemary's Baby?
He's in the White House.
> *Philadelphia,*
> *1969*

Make love during the safe
period – when her husband's
away.

Elwood, Ind.

This is the only city where a
man of modest means can live like
a queen.

*San Francisco,
Cal.*

Jean-Paul Sartre didn't suffer
from this trouble.

ladies, Farnham

BOBBIE SANDS
IS FREE

— so was the
food!

*Belfast, 1981
(also seen in
Vancouver)*

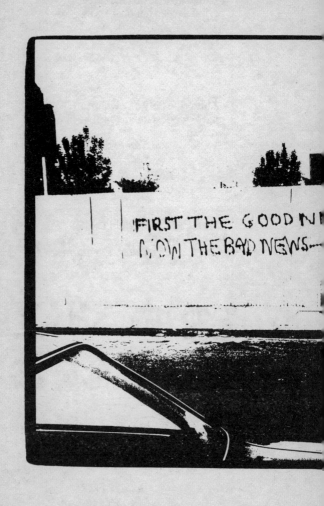

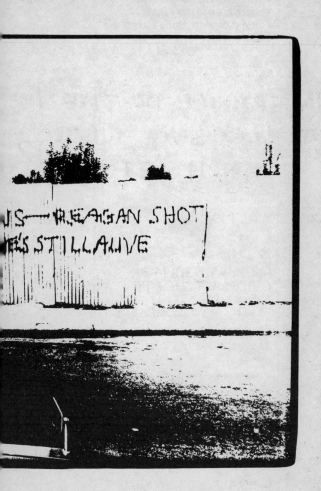

I was asked three questions
about Sartre in my Finals.
I didn't write anything and got a
First.

Oxford

IN FRANCE DO THEY PLAY SCRABBLE WITH FRENCH LETTERS?

Northampton

I SCREWED SIXTY-SIX
GIRLS LAST SUMMER
– uhuh.

Batesville, Miss.

****** ****** has swallowed
more seamen than the Bermuda
Triangle.

Cardiff

LEGALIZE CANNABIS
NOW – and we'll all go to pot.

London W11

Sex is like a snowstorm—you never know how many inches you'll get or how long it will last.
Bradford

Sex is like a bank account. After you withdraw you lose interest.
Reigate

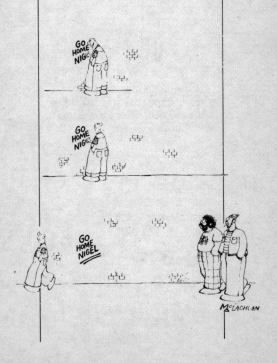

Resprays

Graffiti themes that have already appeared in **Graffiti 1, 2** and **3,** subjected here to yet more variations:

I'D GIVE MY RIGHT ARM TO BE AMBIDEXTROSS —and my left arm to be able to spell it.

Cardiff

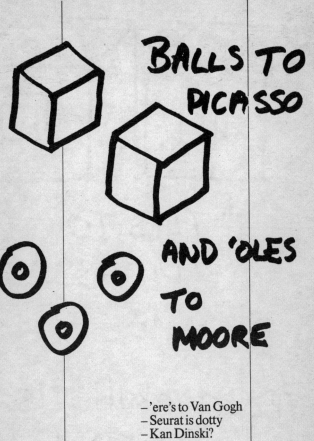

BALLS TO PICASSO

AND 'OLES TO MOORE

– 'ere's to Van Gogh
– Seurat is dotty
– Kan Dinski?

– THIS IS MIRO WRITING

Lemon Tree pub,
London WC2

Resprays

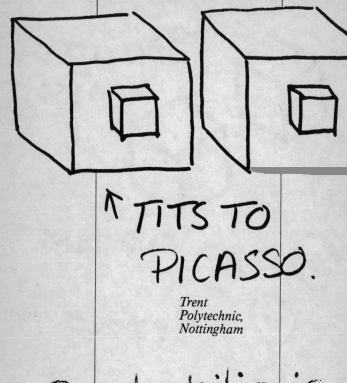

↖ TITS TO
PICASSO.

Trent
Polytechnic,
Nottingham

Paedophilia is
child's Play

Hertford

ASHES TO ASHES
DUST TO DUST
WHAT IS A SWEATER
WITHOUT A
BUST?

Mainz, 1907 (sic)

Ashes to ashes
Dust to dust
If it weren't for pussy
My dick would rust.
*Los Angeles, Cal.
1980*

Resprays

125

THIS PROSE,
THE RHYMES AND
PROVES WILL
HERE DID SIT

My literary friend
you are mistaken,
This is the work of
Francis Bacon!

Durham

WONDROUS WIT
SHAKESPEARE

IT'S NO USE STANDING
ON THE SEAT THE CRABS
IN HERE CAN JUMP TEN
FEET
— If you think that's fucking high
Go next door: the bastards fly.
— Swinging from chains and such
resources
Is laughed at by their airborne
forces
— That ain't the reason, it's a
cunning wrangle
To give my bollocks room to
dangle.

Cambridge /
Rowcroft Lines,
Singapore /
Castle Meadow,
Norwich — all
during World
War Two

Resprays

When God made man she was
having one of her off-days.
Covent Garden

WHEN GOD MADE MAN
SHE WAS ONLY JOKING
– and woman was the punchline.
Birmingham

I LIKE SHEEP
– it's me and ewe, babe!
Stoneham,
Mass.

I LIKE SADISM,
NECROPHILIA, AND
BESTIALITY. AM I
FLOGGING A DEAD
HORSE?
– no, just an old joke.
Grantham
station

HEADS

don't shout.

London W1

IF AT FIRST YOU
-SO MUCH FOR

Shoreditch

Old weight-watchers never
die. They simply fade away.
Glasgow

Old lawyers never die. They
simply lose their appeal.
Manchester

Old TV directors never die.
They simply fade to black.
London W12

Old D.I.Y. enthusiasts never
die. They just get plastered.
West Bromwich

DON'T SUCCEED..
KY-DIVING.

I used to believe squat thrusts were a gym test until I discovered Greek toilets.
London W1

Star-date 24 13 mark 7.
Beamed down for a pee.
Spock.
Belfast

NORMAN ST JOHN STEVAS' LIPS ARE SEALED – so are Margaret Thatcher's, that's why she talks like that.
Newport, Gwent

John Stonehouse is not a stranger to the truth. They haven't even been properly introduced.
Camberwell, 1974

UP THE
UP THE

UP Y

Contemplating suicide? Drink
French polish. Horrible death,
beautiful finish.
Folkestone

Superman gets into Clark
Kent's pants every morning.
Boston, Mass.

BLACKS!
REDS!
~URS?!

Sᴜᴛᴄʟɪꜰꜰᴇ ɴᴏᴛ ᴍᴀᴅ,
ᴍᴀʟᴇ

*Highgate, after
trial of Yorkshire
Ripper, 1981*

Sᴜᴘᴘᴏʀᴛ ʏᴏᴜʀ ʟᴏᴄᴀʟ
ᴛᴀxɪᴅᴇʀᴍɪsᴛ. ɢᴇᴛ sᴛᴜꜰꜰᴇᴅ.
Wells

Oh No, Not the singing telegram!

*Oxford Circus
Underground
station*

Q. What is a Texan virgin?

A. A girl who can run faster than her brother.

Dallas, Tex.

Why do so many screwballs write graffiti instead of going to shrinks? Writing graffiti doesn't cost $40 per hour.

Chicago, Ill.

*I*N AUSTRALIA I WILL!
— become a whinging pommy
bastard.

> *addition to*
> *migration poster,*
> *London WC2*

*T*HINK IT. DON'T SAY IT.
— when you are in front of the
commanding officer.

> *addition to World*
> *War Two security*
> *slogan, Leeds*

*R*eflect all ye that sit at ease,
The sailors on the stormy seas,
The U-boats taking sudden toll —
Go easy on the toilet roll.

> *gents, Chivenor,*
> *during World*
> *War Two*

For the rules of toilet tennis
see opposite wall

> *on the opposite*
> *wall it said: 'For*
> *rules of toilet*
> *tennis see*
> *opposite wall',*
> *M4 service area*

Is a Buddhist Monk refusing trying to transcend dental medication?

Ilkley College,
N. Yorkshire.

I need trepanning like I need a hole in the head.
London WC1

When the Queen is home they run up a flag.
When Mrs Thatcher is home they run up a side street.
Hertford

He who eats another's herbs in Lent lives on borrowed thyme.
Woodford Green

injection at the dentists

Keep Wales tidy. Throw your
rubbish in England.
Oswestry

PEOPLE WHO DON'T
RUN AWAY FROM
TROUBLE – but start it.
*amendment to
police recruiting
poster, London
W8*

The three ages of man:
TRI-WEEKLY
TRY WEEKLY
TRY WEAKLY
traditional

There are two kinds of people
in the world – those who divide the
world into two kinds of people and
those who don't.
*University of
Liverpool*

UFOs are real. Neasden is an hallucination.

Cambridge

WILSON IS A LITTLE SCILLY !

Westminster, 1960s

You can't say the job is finished until the paperwork is done.

ladies, Carmarthen

JESUS IS THE ANSWER
– what's the question?

Altrincham

Barad-dûr boot boys rule Middle-Earth, OK.

Cambridge

JESUS LIVES IN HEAVEN. LOVE GOD AND EACH OTHER
– and The Valves.

London W11

VERSICLE
PRAYER
RESPONSES
PSALM
PRAYER
ANTHEM
– a case of undescended versicle.
Birmingham

Q. Why don't Oxford women
use vibrators?
A. They chip their teeth.
Oxford

Don't vote. You'll only
encourage them.
Oxford

Don't be vague, starve a taig.
*Belfast (Taig is
slang for
Catholic)*

Is the Vatican a house of
Pill Repute?

Doncaster

Women who seek equality
with men lack ambition.
Isle of Thanet

Q. What has 27 teeth and holds
back the incredible hulk?
A. My zipper.
Amsterdam

For an adequate time, ring
Cathy ************
Tunbridge Wells

This wall was dictated by Mr
Chad and signed in his absence.
London W1

THE MONA LISA

WAS FRAMED
Birmingham

Think of the money saved if
Steve Austin had worn a seat belt.
San Francisco

I LOVE YOUNG GAYS
-SO DO m I
ʌ
Covent Garden

Home is where the television is.
Covent Garden

ONAN WAS A WANKER.
Covent Garden

Q. WHAT'S OLD AND WRINKLED AND SMELLS OF GINGER?
A. Fred Astaire.
Covent Garden

Old informers never die: they are just put out to grass.
Great Malvern

DOES THE NAME PAVLOV
RING A BELL?
Cardiff

Acknowledgements

For helping in gathering material for this book, I am indebted to:

Patrick, Paul and Sue (in Australia), especially; Beryl Cail; John Cone (in Dallas); Barry Day (in New York); Rennie Ellis, author / photographer of *Australian Graffiti Revisited*; Frank Delaney; Kenny Ball; Alan Nixon; Tom Kellock; Nigel Lewis; Ronald Payne; Celia Haddon; Elizabeth Cragoe; Susan Hill; and viewers, listeners and readers of HTV's *All Kinds of Everything*, TCN Channel 9's *Mike Walsh Show*, BBC Radio 4's *'Quote.. Unquote'*, BBC Radio London, LBC News Radio, *Weekend Australian*, and numerous other programmes and publications in the UK, Australia and New Zealand, including:

Paul M. Morrison, Wigan;
P.S. Smith, Harston;
Roger J. Angus, Wellington, NZ;
Beelzebub Donkey-Scabs, Tyne & Wear;
Jos. Meijers, Maastricht, The Netherlands;
Colin Huggett, Sheffield;
J.M. Sexton, Warwick;
David Pritchard, Worksop;
Val Nelson, Downer, ACT;
Neville Penton, Paris 18ème;
John Delzotto, Five Dock, NSW;
Karen Ward, Killara, NSW;
L.R. Ekblom, Woodford Green;
D.M. Burley, Banstead;
S. Gellatly, Edinburgh;
S.J. Williams, Bristol;
Nick May, Canterbury;
S.D. Wain, Aldridge;
R.M. Cameron, Southampton;
Jonathan Burton, Polegate;

Grace Hull, Glasgow;
Rod Cartner, Bristol;
Mrs W.M. Thompson, Huntingdon;
P.C. Lunt, Henfield;
Miss A.B.H. Mullen, Chard;
Mrs S. Graham, Bradford;
Sonia Fraser, Woodbridge;
Steve Horsfall, Hemel Hempstead;
Valerie Knott, Northampton;
Peter Yapp, London SW15;
K.J. Bowyer, Stock;
Mrs H. Osborne, Widford;
Alfred Stone, Dagenham;
R.J. Davis, Branton;
David Griffiths, Brandon, Co. Cork;
Graham Paul, Tunbridge Wells;
Mrs B. Wagstaff, Dunstable;
Peter West, London SW20;
W.J. Watt, Southport;
Reg Thomas, Barri;
David Holbert, Wallasey;
Cherry Lavell, London NW1;
Laurence Henshall, Whitstable;
Mrs. Geraldine Leaman, Repton;
Mrs S. Linegar, Rainworth;
Mrs Thelma Goldring, Dundonald;
Glen Rankin, Bishop's Stortford;
M. Spencer, Salisbury;
K.J. Bowyer, Stock;
Mrs A. Liebenthal, Pinner;
Harry Harrison, Cardiff;
D.J. Hall, Leeds;
J. Zorn, Port Penrhyn;
Roger Eve, Leeds;
Frank L. Kay, Birmingham;
P.M. Coston, Chippenham;
Norman Brade, Cheddar;
E.T. Fearon, London N14;
Robert Edgar, London SW10;
John Watt, Hebden Bridge;
Anthony J. Phelps, West Didsbury;
Nicholas Phillis, Whitstable;
Tim Skelton, Milton Keynes;
etc. etc.

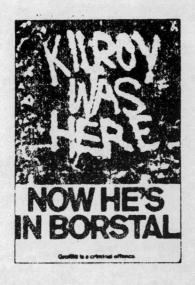

Graffiti Lives, OK
Graffiti 2
Graffiti 3

'a devastating harvest of mural
comment' *Evening News*
'a special art form'
 Liverpool Daily Post
'gems must be preserved for
posterity' *Woman's World*
'will keep the reader amused for
hours' *Yorkshire Post*
'rude, irreverent and uproariously
funny'
'a flashing delight of wit, simple
bawdiness, social comment and
piercing common sense'
 Dick Francis, Sunday Express

also published as
The Graffiti Pack a three-book
boxed set and in a one volume
hardback edition – The Graffiti File

**other books by Nigel Rees in
Unwin Paperbacks**
Quote . . . Unquote
'a great hit . . . packed with
entertaining quotes and quizzes'
 Daily Mirror
Quote . . . Unquote 2
'a magical formula . . . sheer
entertainment' *Yorkshire Post*

**and two collections of The Things
People Say . . .**
Eavesdroppings
Foot in Mouth